EVAN PENNY

EVAN PENNY

essay by Kenneth E. Silver

SPERONE WESTWATER

415 West 13 Street New York 10014
212/999-7337 (fax) 999-7338
www.speronewestwater.com

Evan Penny: The Flesh is Weak

The thrusting diagonal of Evan Penny's newest self-portrait (*Self, variation #1*) sets it apart from the classical balance that distinguishes his other recent sculpted figures. Several of these, of course, are notably grotesque, like *Male Stretch, variation # 3*, a more than six-foot-tall freakishly elongated head, and *Panagiota: Conversation # 1, variation #2*, the bust-length figure of a dark-haired woman in a striped tank top monstrously multiplied by time-photography. But both these strange creatures, as well as all the other faces and bodies that inhabit the Penny arcade, circa 2009, nonetheless obey an unspoken law of planar decorum. Penny's men and women are implicitly cognizant of the two-dimensional realm that is the normal, nurturing environment for this kind of imaginative, highly colored illusionistic representation. Penny's is a three-dimensional world with deep allegiances to Flatland.

Penny's self-portrait, on the other hand, cuts through space in a manner that might rightly be called phallic, its size and powerful diagonal movement, up and out into the spectator's space, almost aggressive. I say almost, since the artist's quizzical expression pulls back on some of the assertiveness produced by the sheer scale of his enormous head and four-feet-wide shoulders. This is not the first time that Penny has invoked the diagonal for its radical difference from the gridded, vertical and horizontal orientation of pictorial art. His Anamorphic Projections of the late-1990s began as art-historical slides of sculpture that he turned into low reliefs angled off the wall into the gallery space. But Penny *himself* is now the embodiment of diagonal thrust; that he allows his own image to aggress into our space in this way bespeaks the attainment of enormous confidence. For an artist who began making figurative sculpture in the 1970s, this is no mean feat.

Like so many young artists of his generation, Evan Penny had to fight his way out of the esthetic and moral lockdown of abstraction. What for Picasso, Kandinsky, and Mondrian had been a liberating idea, and decades later still had the power to inspire both Jackson Pollock's extravagances and Barnett Newman's austerities was, by 1970, a system of proscriptions, epitomized by the writing of Clement Greenberg. As Penny himself has said: ". . . there was still this crisis: how can you be a contemporary

artist and a figurative sculptor? It was perceived as a contradiction in terms."[i] The reigning artistic ideology of the period, Greenberg's neo-Kantian notion of modernist "progress," whereby art was reduced to the conditions of its own production, was essentially an argument about painting, not sculpture. Abstraction meant flat rectangles, and only sculpture that prioritized the pictorial was considered serious. Clement Greenberg himself had come to Canada and famously led a seminar for artists at Emma Lake, Saskatchewan, in 1962; his ideas were thus still very much in the air when Evan Penny was in college and graduate school at Alberta College of Art in the 1970s. "I don't think you could be an artist in Alberta through those years," he's explained, "and not be aware of Greenbergian formalism. You had to have some kind of relationship to it and I certainly did. You simply had to work through it."

Penny had the good luck to come into contact with Anthony Caro, the most important of the abstract (Greenberg-approved) sculptors in the post-David Smith generation, who, surprisingly, advised him to pursue figurative sculpture rather than the sort of constructivist, abstract work he was embarked upon. This encounter gave Penny the courage to work his way out of the "real crisis," as he called it, of adhering to formalist abstraction, and it probably accounts for why his figuration always feels built upon a solid foundation of abstract forces. Doesn't the way that *Self, variation #1* exceeds its base, pushing into surrounding space, remind us of Caro's "Table Pieces" of the mid-1970s, or of the cantilevered, minimalist, monumentalism of a Robert Grosvenor or Ronald Bladen sculpture? And is it only an accident that Penny's sculpture, even now, hews so closely to pictorial art, that for all the appearance of rotundity most of his figures are closer to relief in their flatness than sculpture-in-the-round? It's as if this insistence on the grid of two-dimensional art as the starting point for three-dimensional representation were insurance against sculptural naivety, or glibness.

And yet, this first crisis of Penny's artistic faith—having to give up on the nearly religious conviction of formalism's real if unstated prioritizing of pictorial abstraction—was only the beginning of his long, methodical path towards figural enlightenment. Sculpture, after all, forever runs esthetic, epistemological, and even ethical risks that painting does not. Unlike painting, which is flat like a pancake not fat like the world, sculpture steals its voluptuous three-dimensionality from life

itself. Making figures is akin to making dolls (pseudo-babies) or store mannequins (pseudo-adults), appropriate for children or consumers, but desperately inadequate to satisfy esthetic longing. Isn't that why the stories of misplaced sculptural drive—of Pinocchio's father, Geppetto, or of Pygmalion and Galatea—figure prominently in Western myth and storytelling? That we might forget to see the difference between real living creatures and the things we construct out of a need for love, or thwarted desire, is not unconnected to the Second Commandment. "Do not make an image or any likeness of what is in the heavens above" is not only a warning against idolatry, it's also a succinct way of saying that God is the only sculptor who matters.

Not surprisingly, the word "realism" has been a constant irritant for Evan Penny. "I was never really interested in realist narrative," he's said, and, "I have never thought of myself as a realist." We can well imagine how disagreeable the question of verisimilitude must have been in the early-1970s for a young artist, when the only contemporary models for realist sculpture were Duane Hanson and John de Andrea. Whatever their courage to stand up against the prevailing abstract formalist ethos of the moment, their hyper-realist art was vulgar, not to say viscerally repellent. When Penny, an artist who makes figures whose skin looks lifelike even under the closest scrutiny, says, "I think I am a formalist bred to the bone," he's not only reaffirming his roots in abstract art, he's also talking about the only sure path to that elusive thing we call beauty. For isn't this ever and always the Realist stumbling block, how to make art that is self-consciously imitative of life and yet capable of transcending the cheap thrills and trespasses of mimesis?

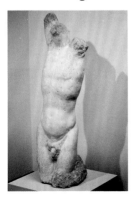

There's the polychrome problem, for instance. Attractive as painted figures may be to the folk artist, they have long seemed hopelessly naïve to the sophisticated sculptor. One way that modern artists, whether Rodin, Matisse, or Lehmbruck [ill.], made certain that the formal qualities of their sculpture would not be overwhelmed by its figural subject matter was by working in monochrome. This coloristic abstemiousness had the added virtue of being "true" to the work's materials: bronze looks like bronze, and only secondarily like brownish or greenish skin; marble looks like marble, only accidentally like whitish skin with

dark gray veins, etc. The ancient Greeks may have painted their Kouroi and Aphrodites in the most lurid of hues, but modern sensibility prefers to imagine them as the ultra-refined monochromatic museum phantoms that have come down to us. Polychrome tends to tilt the sculptural balance away from abstraction, and towards Madame Tussaud.

Yet, as Penny has ineluctably come to recognize, to evade the polychrome question, or many of the other "realist" sculptural possibilities, would be an act of cowardice, a tacit refusal to enter into the figurative arena at its most intense, dangerous yet fraught with possibility. This is one reason that the issue of craft arises so often in his conversation: if we don't suspend disbelief in looking at his figures, we will fail to experience the turmoil—struggling to believe in the ongoing viability of figurative art—that has haunted Penny since he was a child with an inordinate mimetic talent. "It has to be so believable that despite all the features that are telling you that this is not real, this is not believable, this is artifice, another part of you is still believing it, still with it, and is maintaining that dynamic. But you can't get there by avoiding the craft; you have to go right into the craft to do it." As is by now well known, it was Penny's astonishing level of craft that sent Hollywood running after him for special effects models used in films ranging from Oliver Stone's *JFK* (Kennedy's exploded head) to *X-Men*.

It is significant that Evan Penny is a sculptor who first models his figures in clay. This distinguishes him from the "body casters" of the post-George Segal era whose figures, among other things, were thus the same size as the real human beings from whom they were derived, and therefore also identical in size to the spectator. Penny's figures are almost always smaller or larger than real people, which accounts in part for their uncanny quality. Moreover, modeling ensures a liveliness that is all too obviously absent from cast figures. ". . . With an indexical process [i.e. moulds] you can only have less than what was there," Penny explains, "whereas with modeling, a kind of consciousness is brought back into the work. It's the byproduct of many, many conscious decisions, and they are all, whether you are aware of it or not, readable. There is a building of energy that compensates for the lack of life. The more informed and understood an object is, the more complex it is. The more decisions that go into its construction, the more layers of observation there are, the more conscious it becomes, the more intense and dense, and that is the stuff of the hyperreal."[ii] But what, we may ask, keeps figures

that begin in traditional working methods from ending up as neo-traditional pastiches? Penny has asked himself the same question at almost every stage of his career: "The project is, how do you do figurative sculpture and make it relevant and contemporary when the terms are constantly shifting? . . . How do you get figurative sculpture to attach itself to the present?"

One way has been to work in close relationship to what Penny calls the "digital Zeitgeist," to use the techniques, discoveries and visual discursive tropes of computer-generated photography, time-photography, and high-tech lighting as reference points: the distortions of *Male Stretch, variation # 3,* and *Panagiota: Conversation # 1, variation #1,* and *variation 2* are suggested by Photoshop-like image manipulation and time-photography (the latter two resulting from a collaboration with photographer Michael Awad), just as the red, green, and blue washes on *NOIP: RGB, variation #1* derive from theatrical lights falling on a subject. Penny uses the forms of modern media as so many "found" materials, collaging modernity into his art just as surely Georges Braque and Hannah Höch did by way of newsprint and black-and-white newspaper reproduction. But a more important way that Penny has gotten "figurative sculpture to attach itself to the present" has been by persistence, by continuing to mine his vein of hyper-reality right into the post-modern moment, "the era," as W.J.T. Mitchell has described it, "of video and cybernetic technology, the age of electronic reproduction . . . visual simulation and illusionism, with unprecedented powers."[iii] We might well say that the Zeitgeist has finally caught up with Evan Penny avant-gardism, as evidenced by the figural simulacra of Charles Ray, Ron Mueck, Kiki Smith, Maurizio Cattelan, Robert Gober, Damien Hirst, Patricia Piccinini, Mark Quinn, and Paul McCarthy, among others.

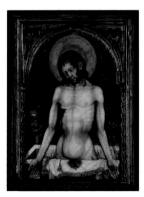

But, in a surprising turn of events, as Penny's figuration has become a kind of *lingua franca* on the current scene, his newest work has veered towards an end-of-the-world timelessness, or perhaps it's eschatological time. For what is the eight-foot-tall (but only 18 inches deep) *Large Murray* if not a Man of Sorrows for the present moment? Like the late-medieval, early-Renaissance image of the half-nude Jesus Christ [ill.], Murray is a figure whose resignation is palpable and whose suffering cries out for compassion. Murray's wounds, such as they are, are no more than the

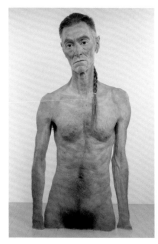

depredations of time, the signs of life's normal wear-and-tear on a middle-aged body. Yet, his sadness (I am tempted to write His sadness) feels exemplary, his aging and endurance a colossal fact with which those of us who survive long enough to recognize wounds like these to our own bodies, and to our pride, must come to terms. Perhaps it was inevitable that Penny, the son of a Christian missionary doctor, would sooner or later find his way back to the Most Exemplary Man, even if he now sports a pigtail tied with a rubber band instead of a crown of thorns. Evan Penny said a few years ago that he decided he "wanted to make extraordinary objects again,"[iv] which sounds like a calling, if there ever was one.

Kenneth E. Silver is a Professor of Modern Art at New York University.

[i] Robert Enright and Meeka Walsh, "The Artful Doubter: Evan Penny and the Making of Extraordinary Objects," *Border Crossings,* Issue no. 98, p. 27. This article includes a lengthy interview with Penny, from which this quote it taken, conducted in Toronto on April 8, 2006. All quotations from Penny below are from this source, unless otherwise indicated.

[ii] Evan Penny cited in Nancy Tousley, "Absolutely Unreal: The Sculpture and Photography of Evan Penny," *Absolutely Unreal*, exh. cat. (London, Ontario: Museum London, 2003), pp. 36-7.

[iii] W.J.T.Mitchell, *Picture Theory* (Chicago and London: University of Chicago Press, 1995), p. 15.

[iv] Evan Penny cited in Sarah Milroy, "Skin Deep," *The Globe and Mail* (March 1, 2004), p. R7.

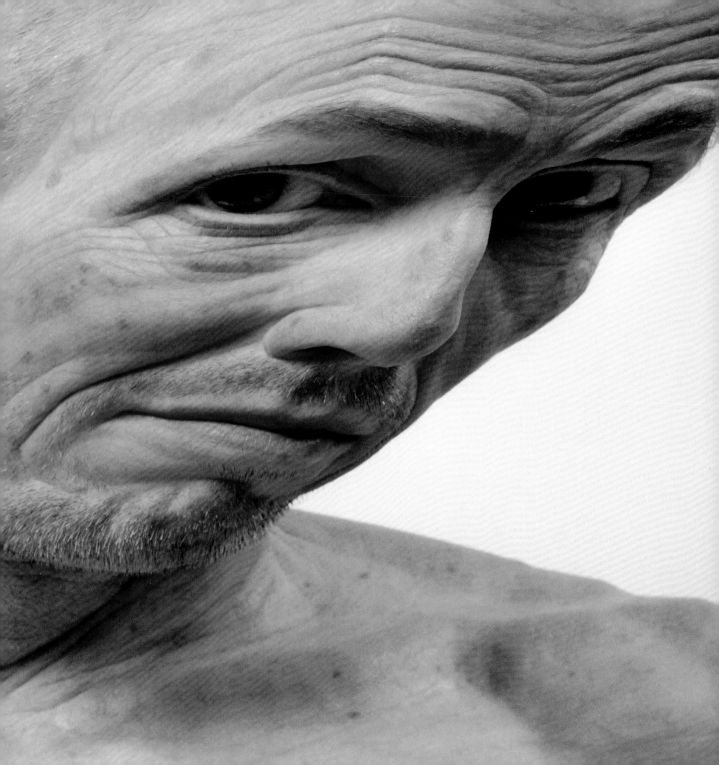

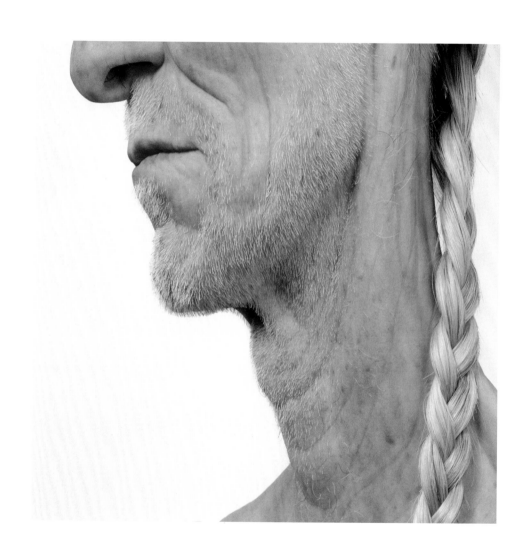

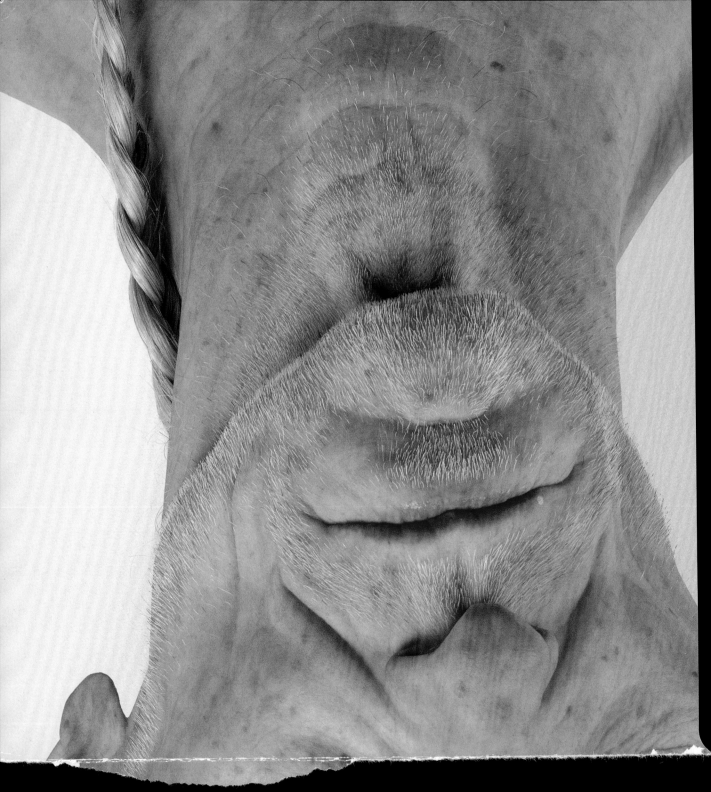

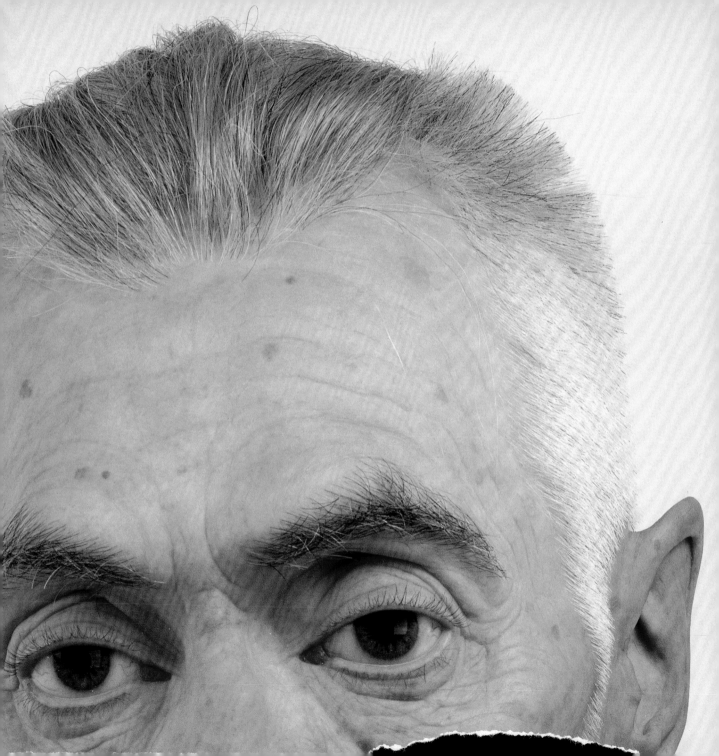

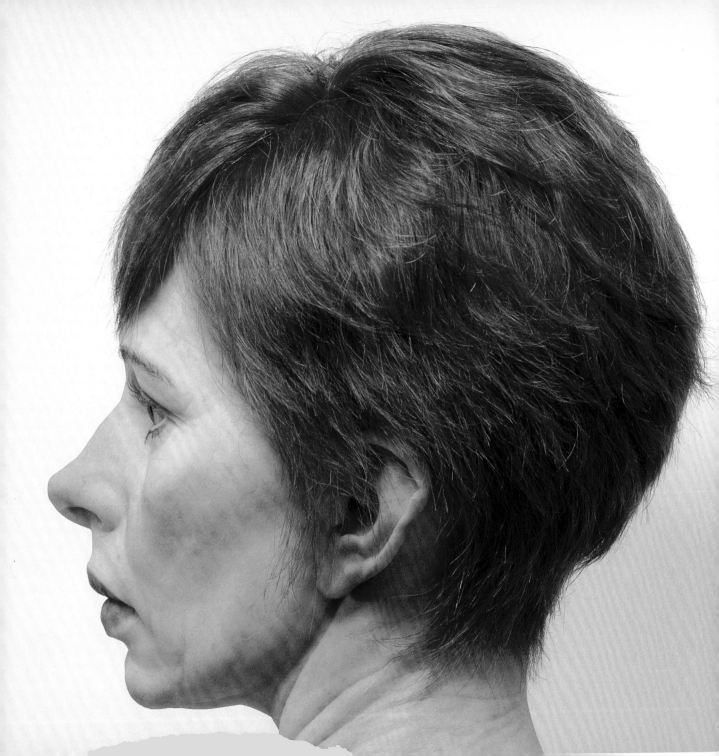

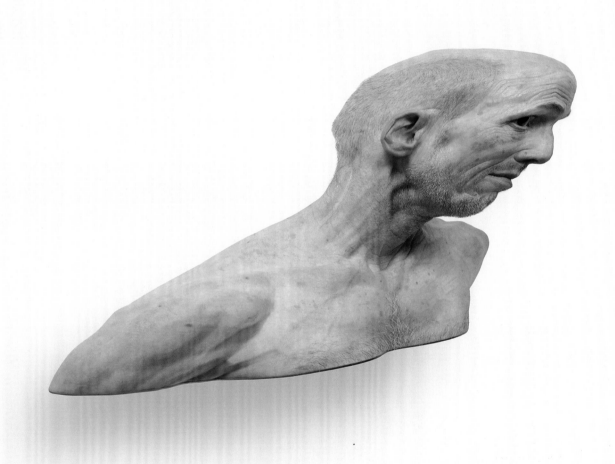

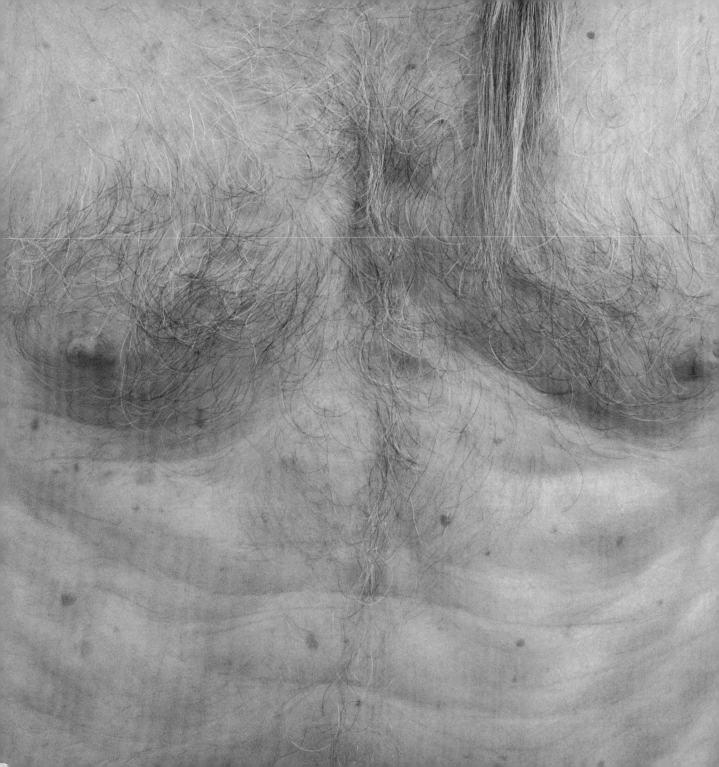

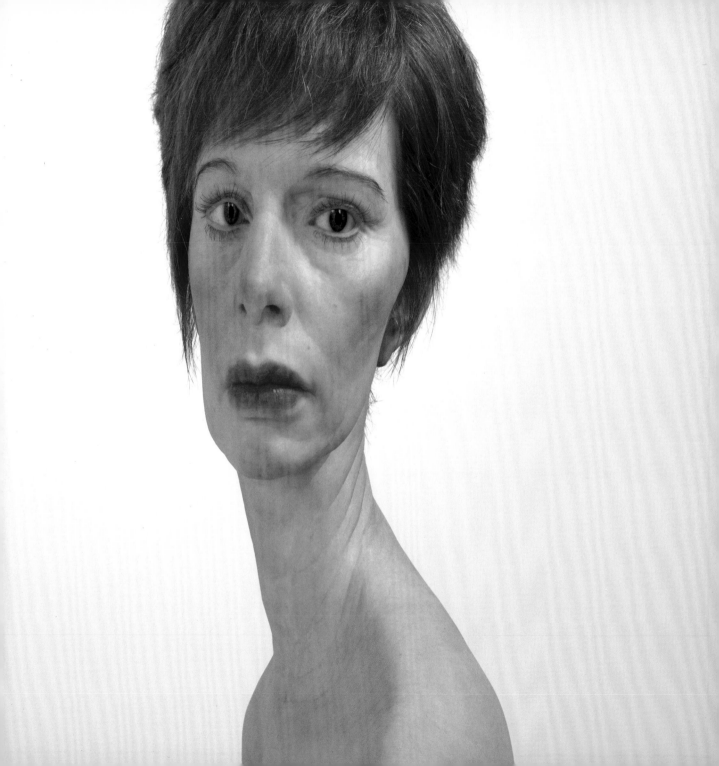

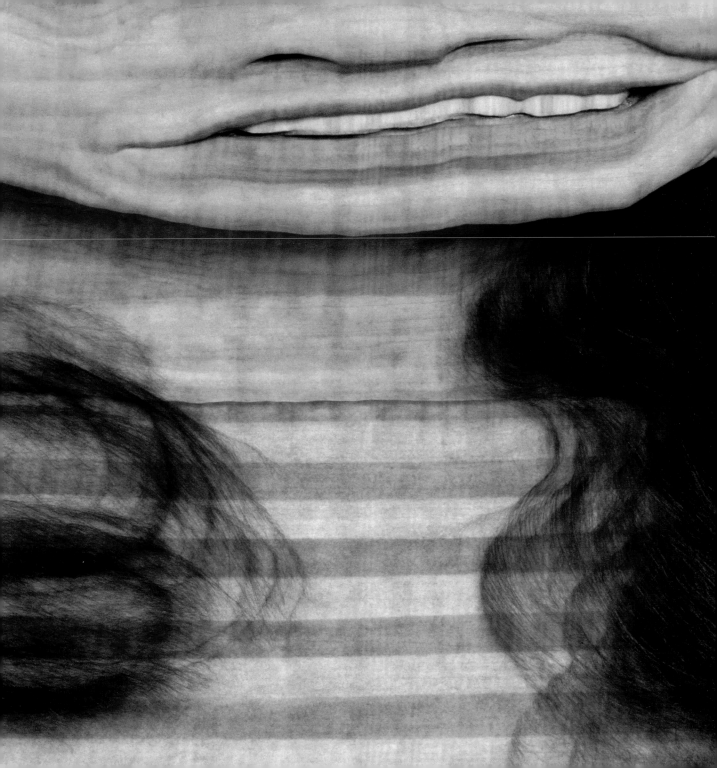

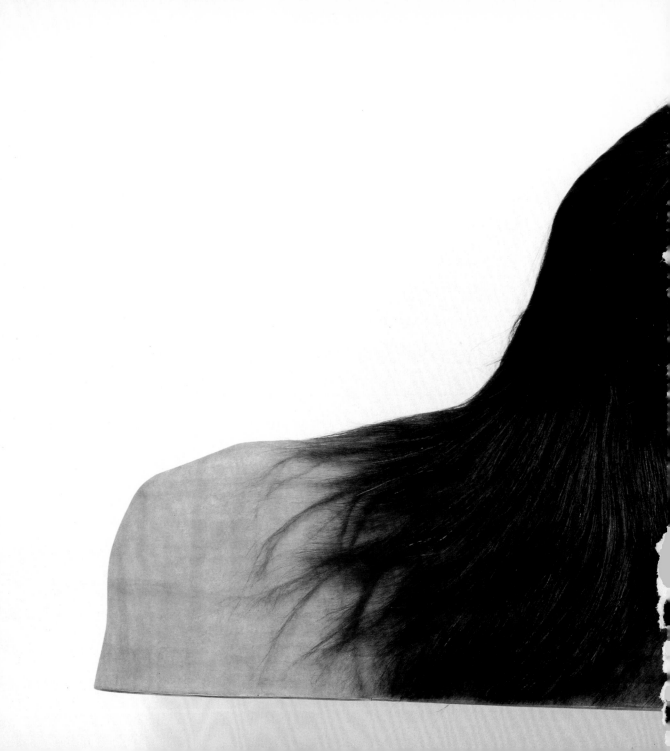

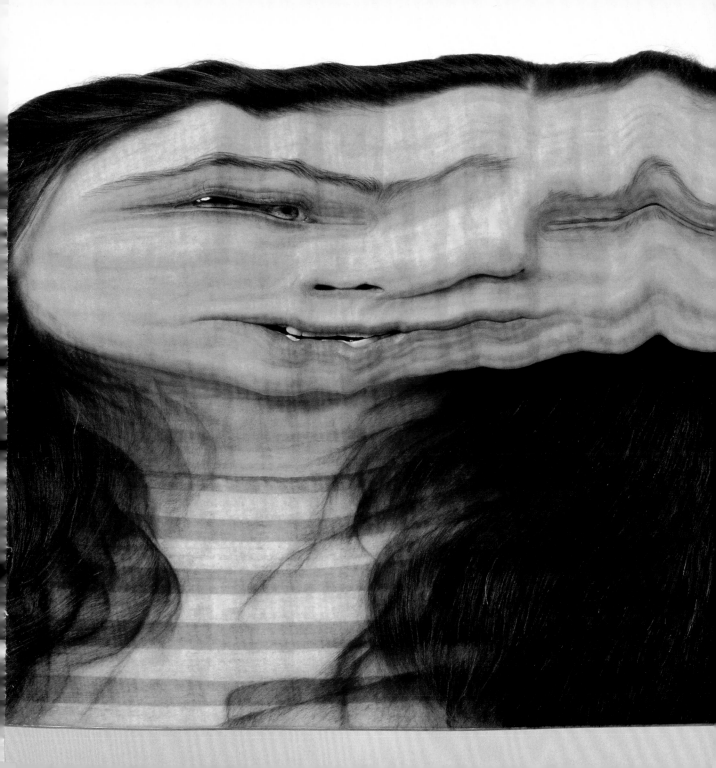

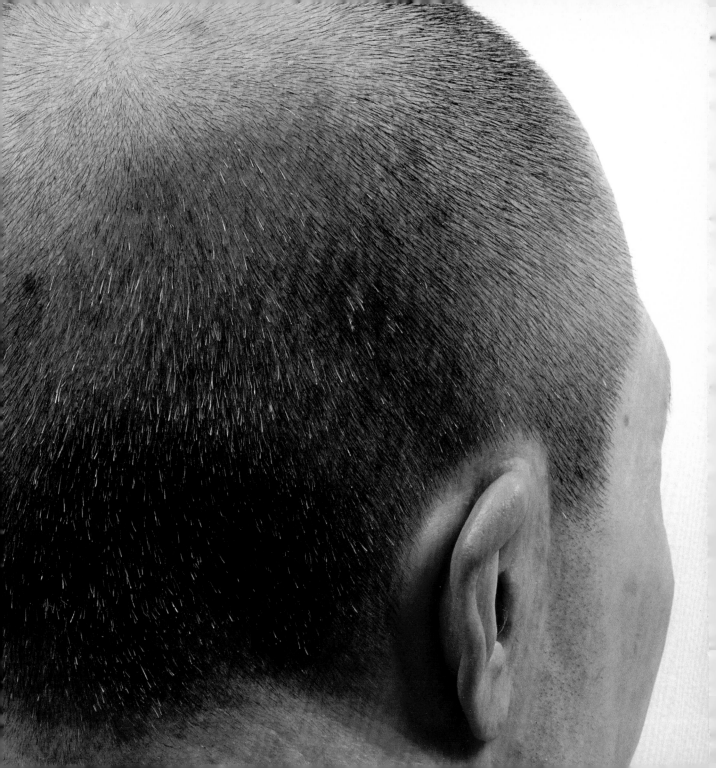

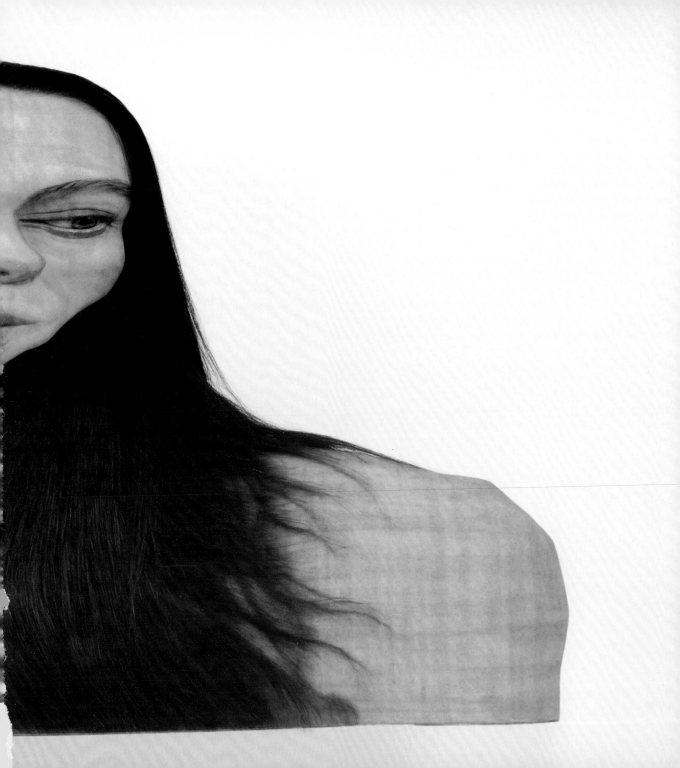

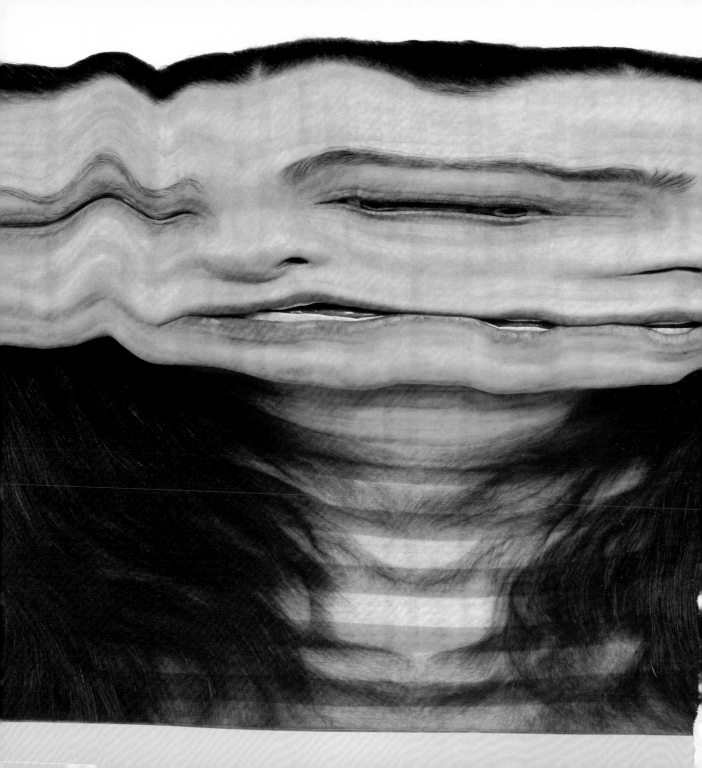

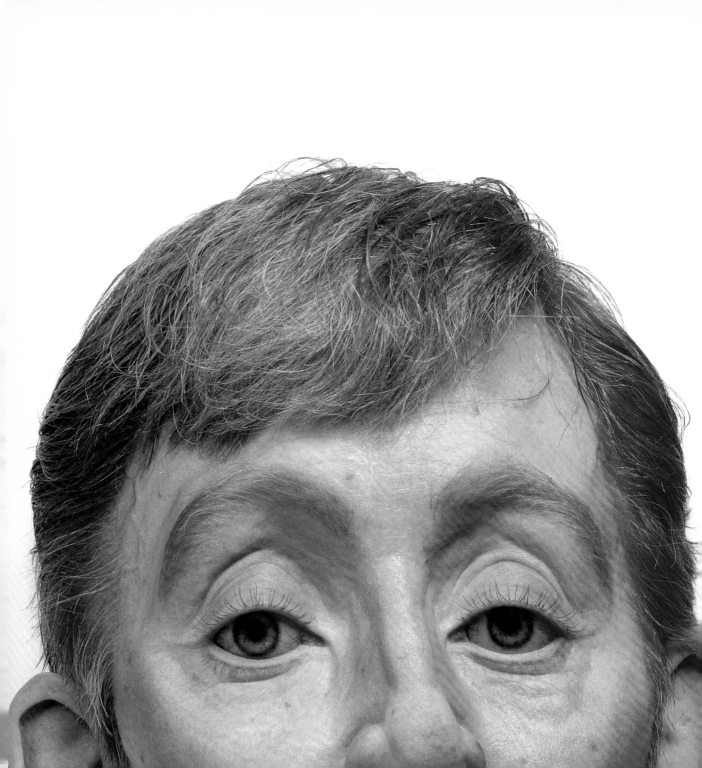

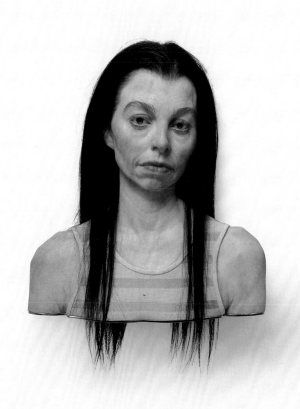

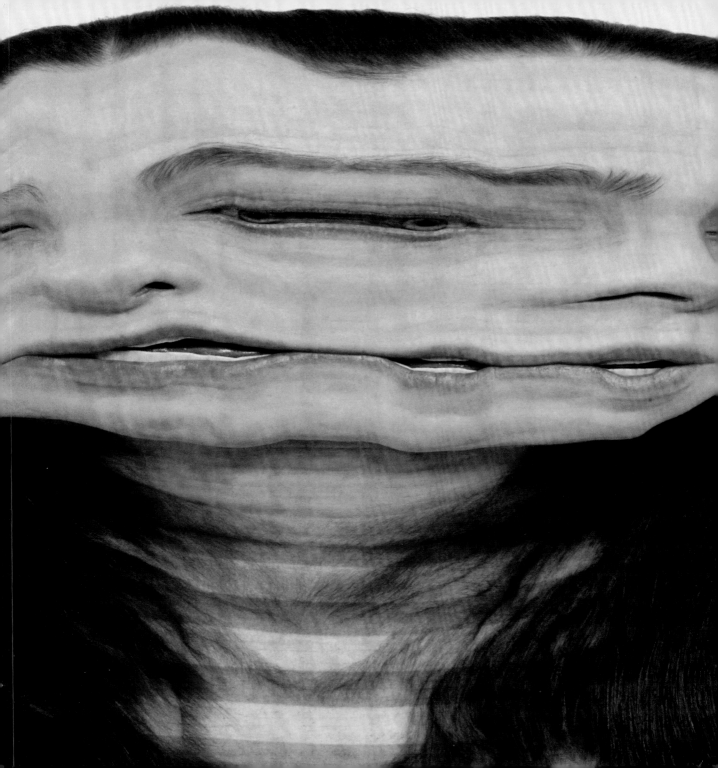

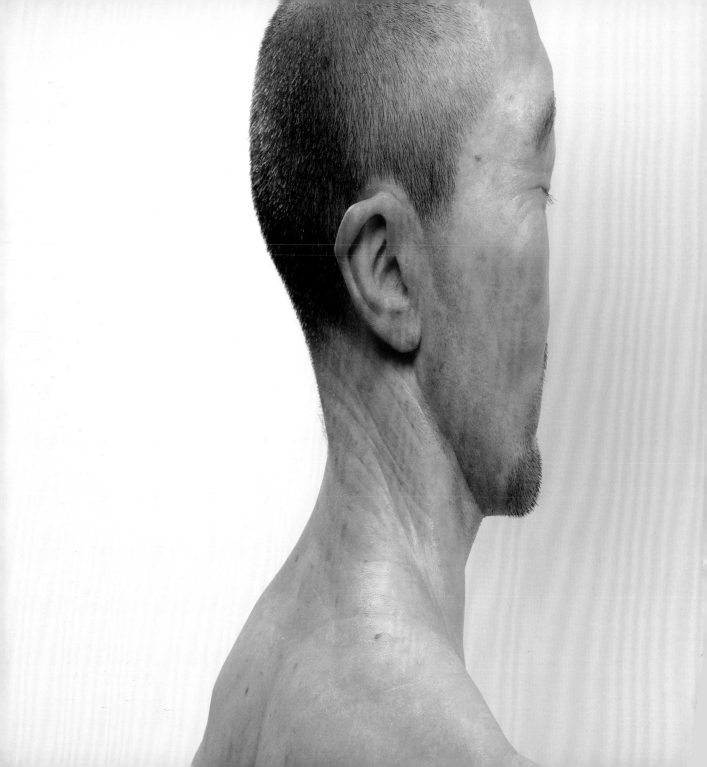

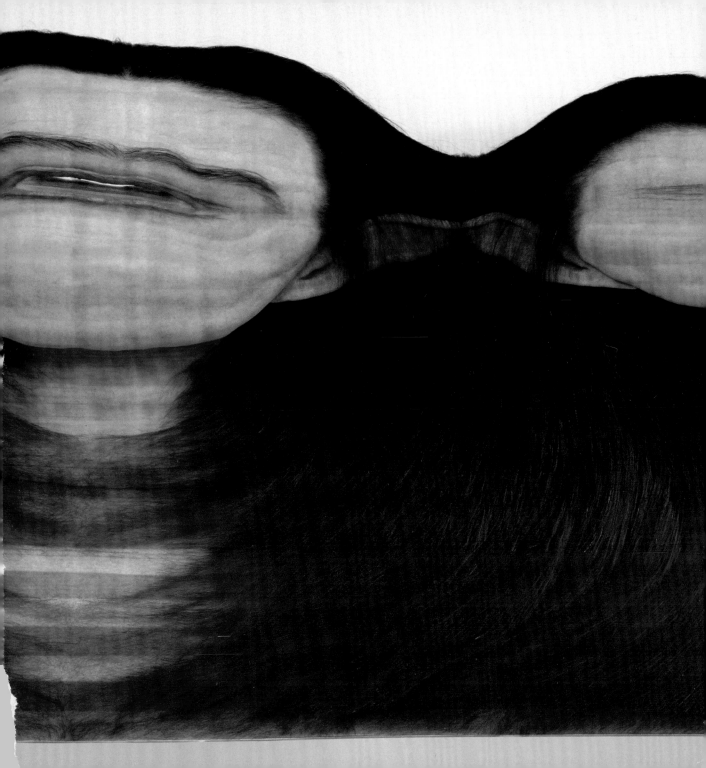

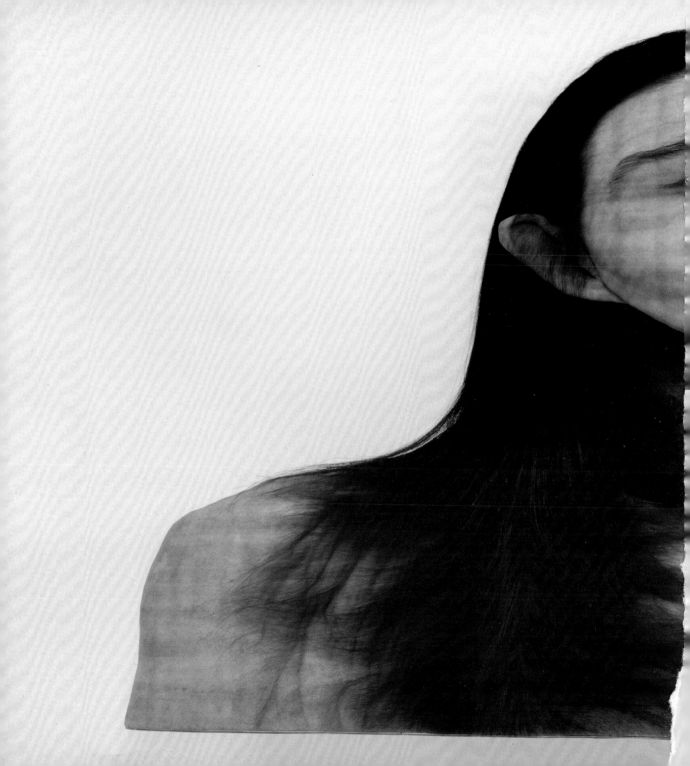

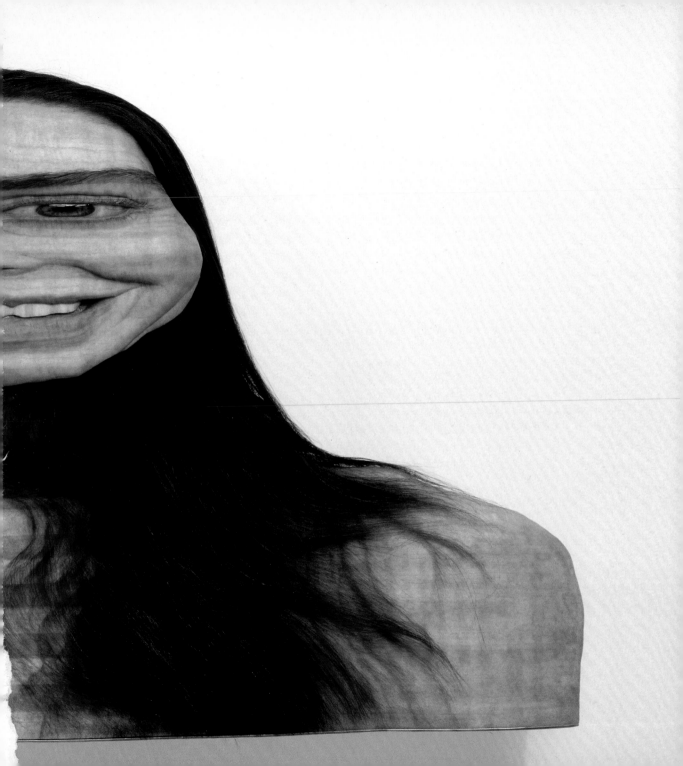

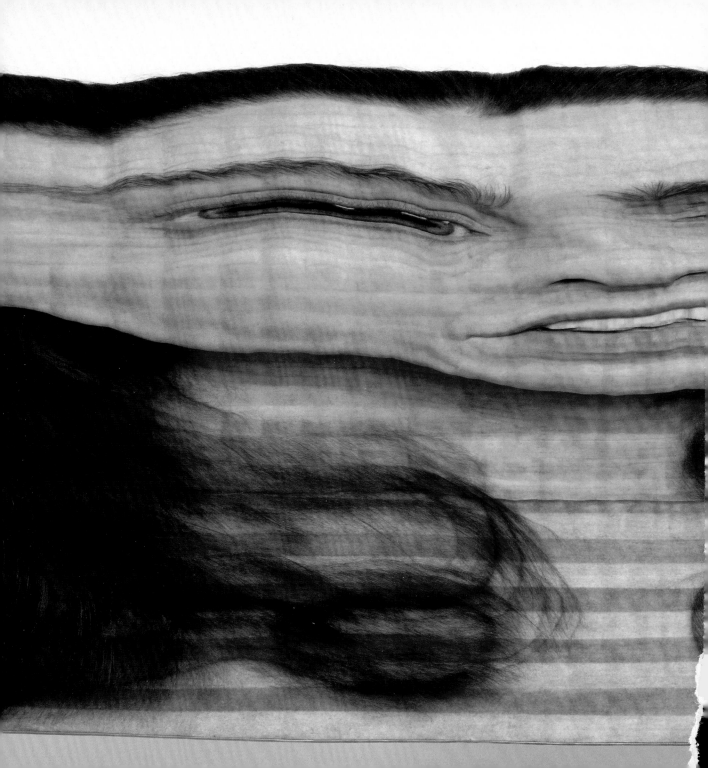

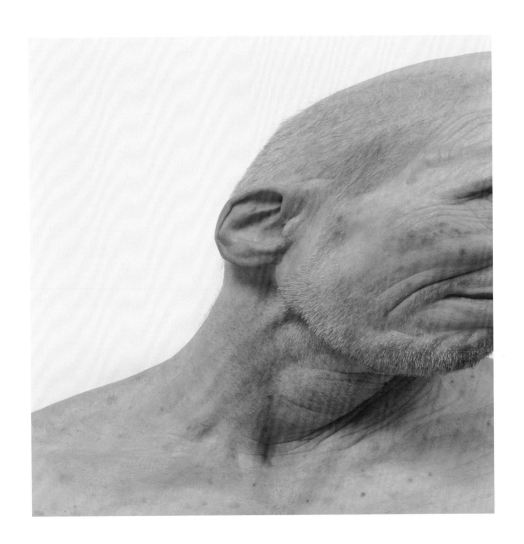

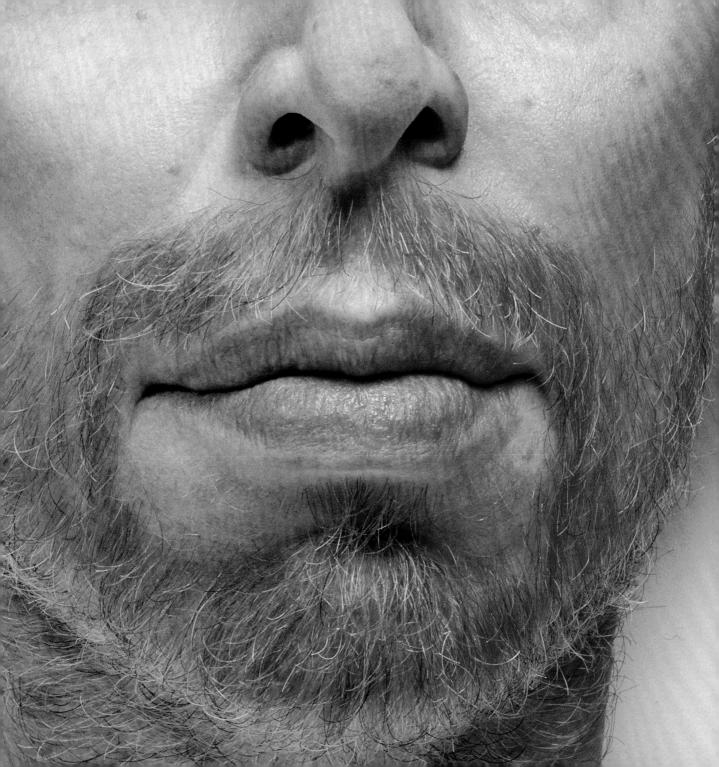

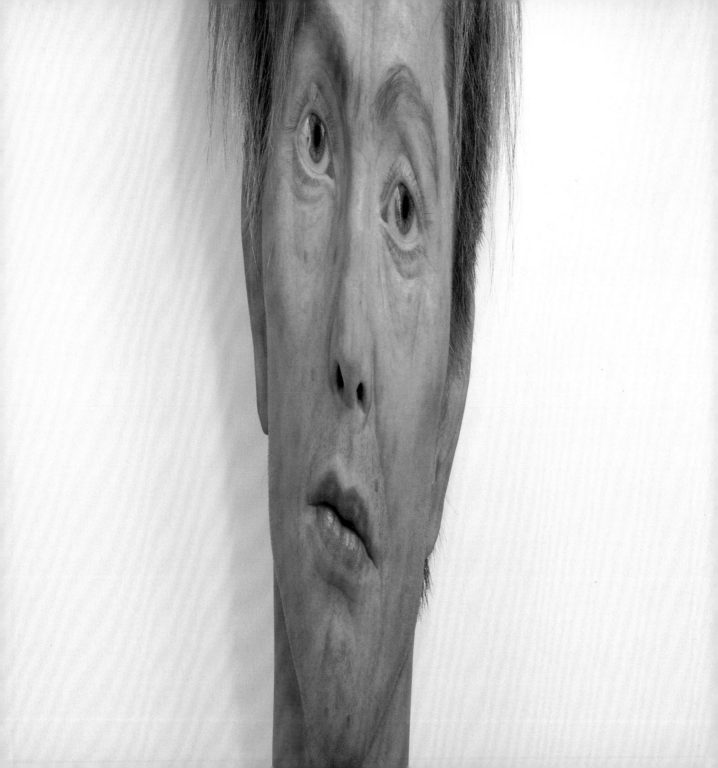

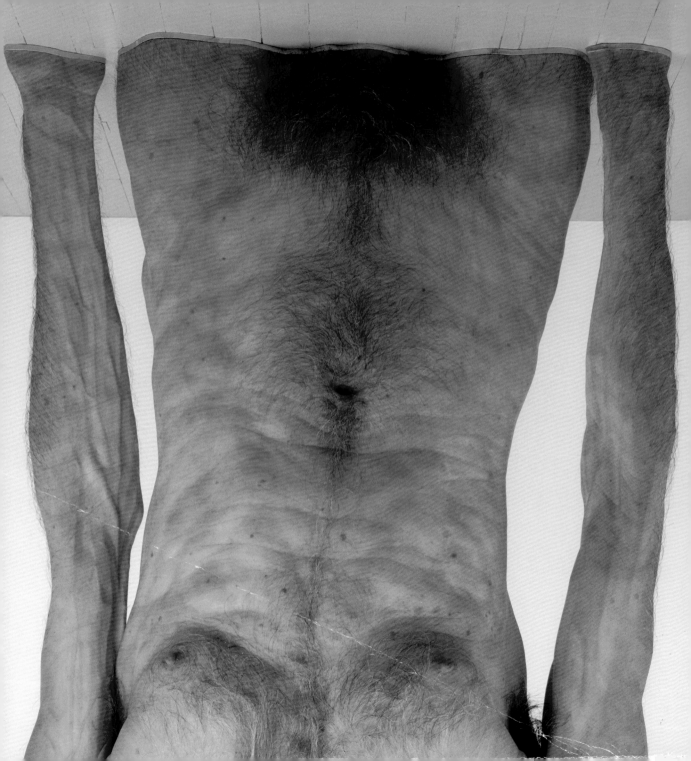

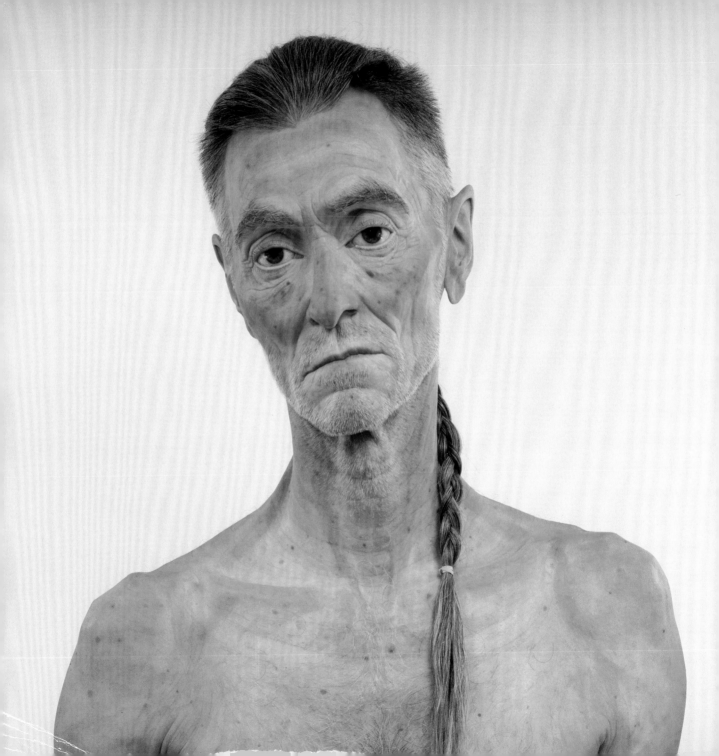

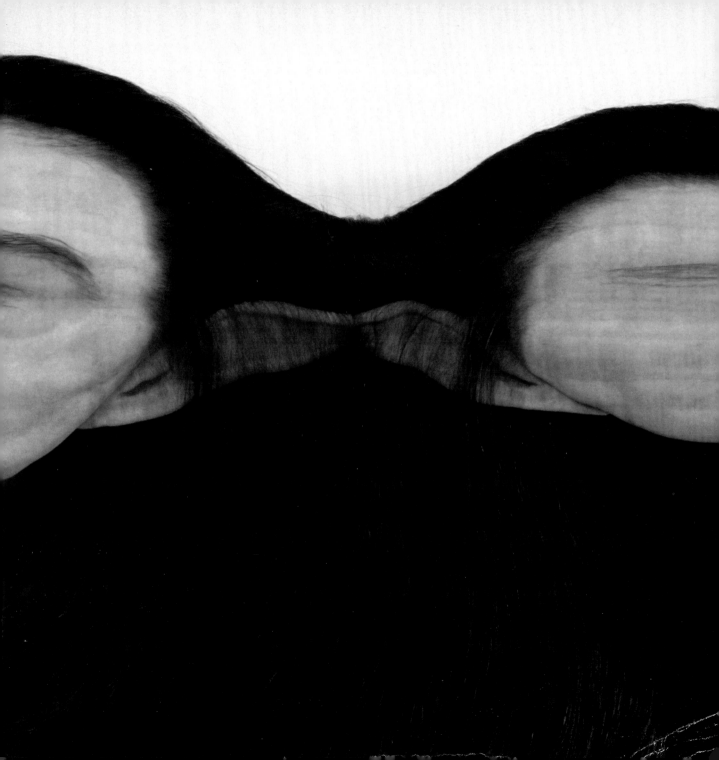

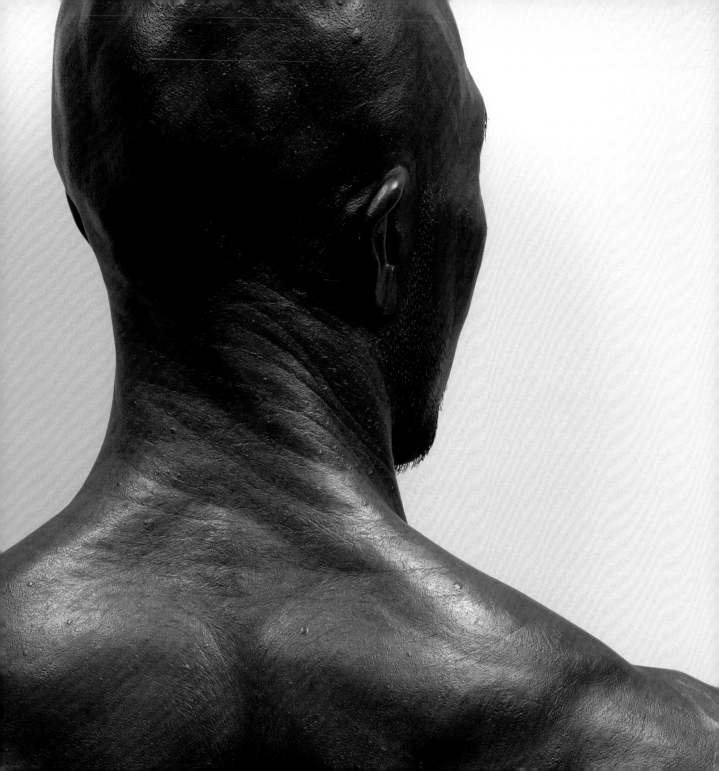

SCULPTURES

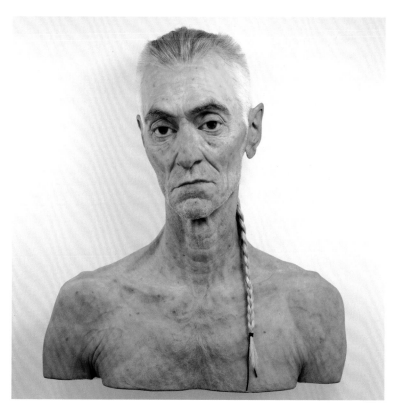

Murray. Variation #3
2008
silicone, pigment, hair, aluminum.
48 x 42 x 13 inches (122 x 107 x 33 cm)

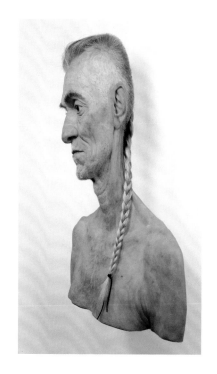

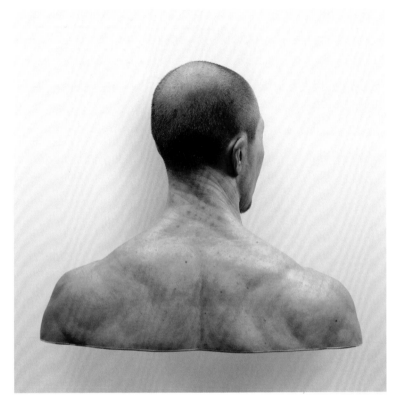

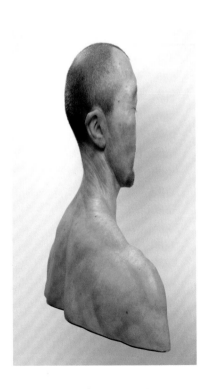

Back of Danny, variation #4
2008
silicone, pigment, hair, aluminum.
24 x 28 1/2 x 6 inches (61 x 72 x 15 cm)

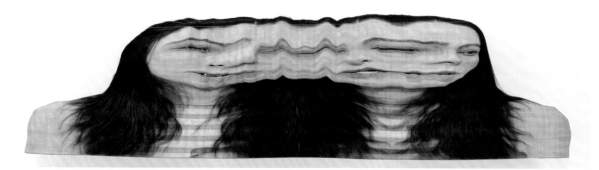

Panagiota: Conversation #1, variation #2
2008
silicone, pigment, hair, aluminum.
27 x 108 1/2 x 6 inches (69 x 275 x 15 cm)

Panagiota: Conversation #2, variation #1
2008
silicone, pigment, hair, aluminum.
28 x 108 x 6 inches (71 x 274 x 15 cm)

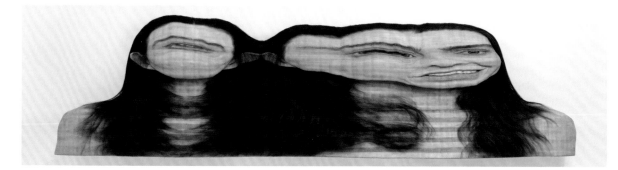

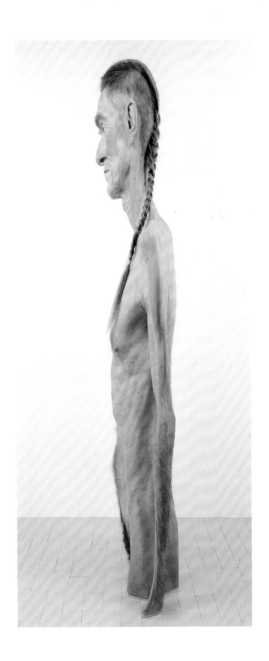

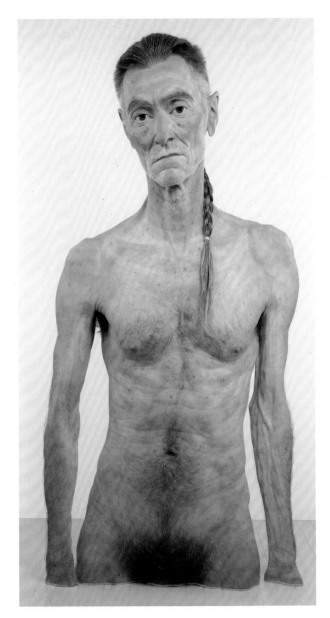

Large Murray
2008
silicone, pigment, hair, aluminum.
96 x 47 x 18 inches (244 x 120 x 46 cm)

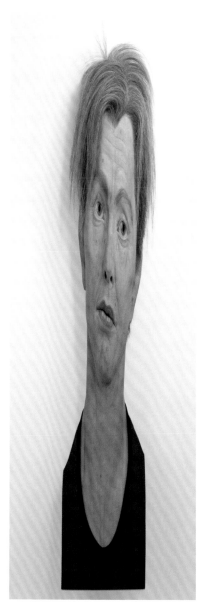

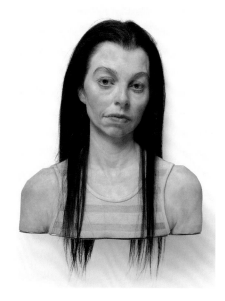

Male Stretch, variation #3
2008
silicone, pigment, hair, fabric, aluminum.
76 x 12 x 6 inches (193 x 30 x 15 cm)

Penny, variation #4
2008
silicone, pigment, hair, fabric, aluminum.
17 x 12 1/2 x 4 inches (43 x 32 x 10 cm)

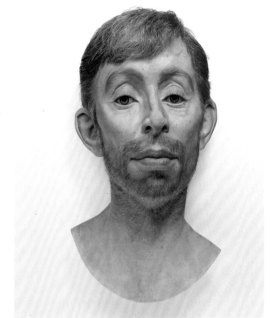

NOIP: RGB, variation #1
2008
silicone, pigment, hair, aluminum.
32 x 16 x 8 1/2 inches (81 x 41 x 21 cm)

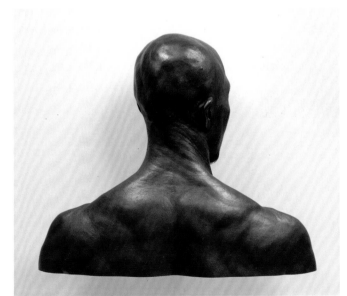

Back of Danny, edition of 5
2008
Bronze.
24 x 28 1/2 x 6 inches (61 x 72 x 15 cm)

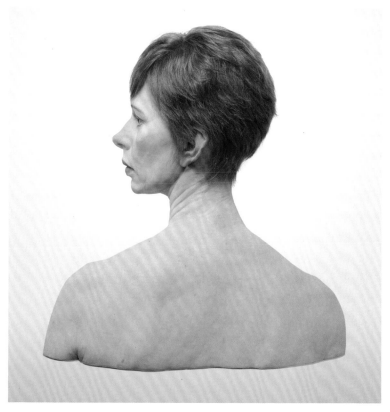

Shelley, variation #3
2008
silicone, pigment, hair, aluminum.
25 x 24 x 7 inches (64 x 61 x 18 cm)

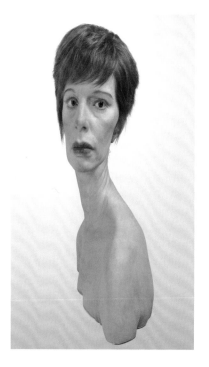

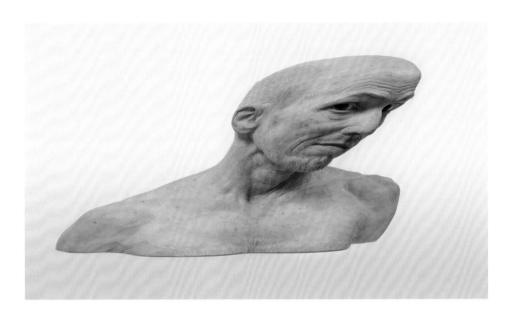

Self, variation #1
2008
silicone, pigment, hair, aluminum.
23 x 46 x 21 inches (59 x 117 x 53 cm)

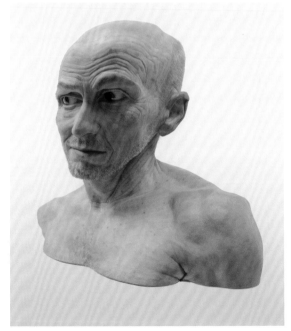

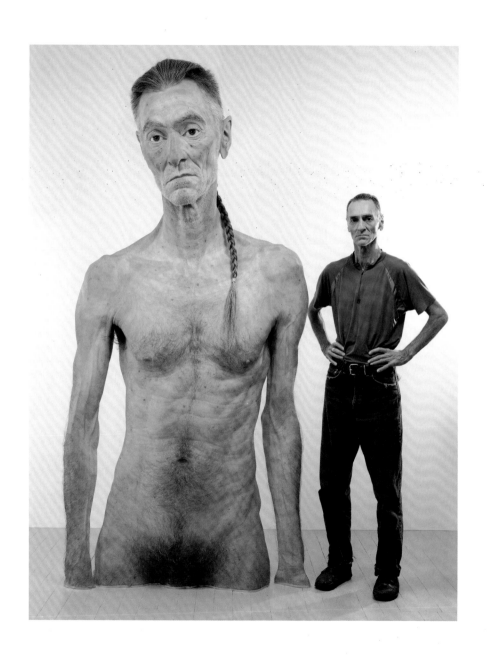

Acknowledgements

I would like to convey my sincerest thanks to those friends and colleagues who participated in and assisted with the production of this work.

A special thanks to Michael Awad and Penny (Panagiota) Dimos for their collaborative roles in the realization of the "Panagiota: Conversation" project.

Evan Penny

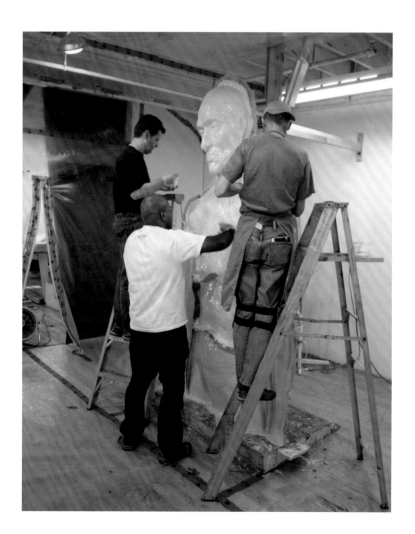

Studio Assistance:
Jay McClennen
Raj Mariathasan
Marie DeSousa
Christy Langer
Naomi Yasui
Norbert Mantik
Samara McAdam

Models:
Murray McKay
Penny Dimos
Danny Yen
Shelley Wildeman

Photography
Evan Penny
Colourgenics Inc. Toronto

Evan Penny

This catalogue is published on the occasion of the exhibition "Evan Penny", presented at Sperone Westwater, New York, 9 January through 14 February 2009.

"Evan Penny: The Flesh is Weak" © 2008 Kenneth E. Silver

Wilhelm Lehmbruck, *Male Torso*, circa 1911, stone, Collection Wilhelm Lehmbruck Museum, Germany

Michele Giambino (Michele Giovanni Bono, Italian, 1420-62, *The Man of Sorrows*, ca. 1430; Tempera and gold on wood, $21^{5}/_{8}$ x 15¼ in. (54.9 x 38.7 cm): The Metropolitan Museum of Art, Rogers Fund, 1906 (06.180), image ©The Metropolitan Museum of Art

Design: Evan Penny and Michael Short

Printed in Montreal, Canada by Transcontinental Litho Acme

Published by Sperone Westwater, 415 West 13 Street, New York, NY 10014

ISBN: 978-0-9799458-5-4